S0-AHX-547

	DATE DUE		

704
SON Sonneborn, Liz.
 Arts and crafts
 C. 1

WALT DISNEY SCHOOL
LIBRARY

NATIVE * AMERICAN * CULTURE

ARTS AND CRAFTS

Liz Sonneborn

Series Editor
Jordan E. Kerber, Ph.D.

* * *

WALT DISNEY MAGNET SCHOOL

ROURKE PUBLICATIONS, INC.
Vero Beach, Florida 32964

704
SON

©1994 by Rourke Publications, Inc.

All rights reserved. No part of this book may be reproduced or utilized in any form or by any means, electronic or mechanical including photocopying, recording, or by any information storage and retrieval system without permission in writing from the publisher.

Printed in the United States of America.

A Blackbirch Graphics book.

Library of Congress Cataloging-in-Publication Data

Arts and crafts / by Liz Sonneborn.
 p. cm. — (Native American culture)
 Includes bibliographical references and index.
 ISBN 0-86625-539-7
 1. Indians of North America—Art—Juvenile literature. 2. Indians of North America—Industries—Juvenile literature. [1. Indians of North America—Art. 2. Indians of North America—Industries.] I. Title. II. Series.
E98.A7S68 1994
704'.0397—dc20
 94-5532
 CIP
 AC

Contents

Introduction

The words "Native American" and "Indian" create strong images for many people. Some may think of fierce warriors with bows and arrows, tomahawks, and rifles who battled the U.S. Cavalry in the days of the Wild West. Others probably imagine a proud and peaceful people who just hunted buffalo and lived in tipis on the Great Plains. These are just some of the popular stereotypes of Native Americans, and like most stereotypes they give a false impression.

This series on *Native American Culture* presents six books on various aspects of Native American life: tribal law, childrearing, arts and crafts, daily life, spiritual life, and the invasion by Europe. By reading these books you will learn that there is no single Native American culture, but instead many different ones. Each Native American group or tribe in the past, as well as today, is a separate nation. While tribes may share some similarities, many are as different from one another as the English are from the Spanish.

The geographic focus of the series is the North American continent (United States and Canada), with special attention to the area within the present-day United States. However, Native Americans have lived, and continue to live, in Central America and South America. In addition, the authors of each book draw upon a wealth of historical information mainly from a time between the 1500s and 1900s, when most Native Americans were first contacted by European explorers, conquerors, and settlers. Much is known

*

5

about this period of Native American life from documents and observations recorded by Europeans who came to North America.

It is also important to understand that Native Americans have a much longer and more complex history on the continent than just the past 500 years. Archaeologists have excavated ancient Native American sites as old as 12,000 years. The people who lived at these sites were among the first residents of North America. They did not keep written records of their lives so the only information known about them comes from their stone tools and other remains that they left behind. We do know that during the thousands of years of Native American settlement across the continent the cultures of these early inhabitants changed in many important ways. Some of these cultures have disappeared a long time ago, while others have survived and continue to change today. Indeed, there are more than 1.5 million Native Americans currently living in the United States, and the federal government recognizes over 500 tribes. Native Americans are in all walks of life, and many still practice traditions and speak the languages of their ancestors. About 250,000 Native Americans presently live on some 278 reservations in the country.

The books in this series capture the wonderful richness and variety of Native American life from different time periods. They remind us that the story of America begins with Native Americans. They also provide more accurate images of Native Americans, images that I hope will enable you to challenge the stereotypes.

Jordan E. Kerber, Ph.D.
Director of Native American Studies
Colgate University

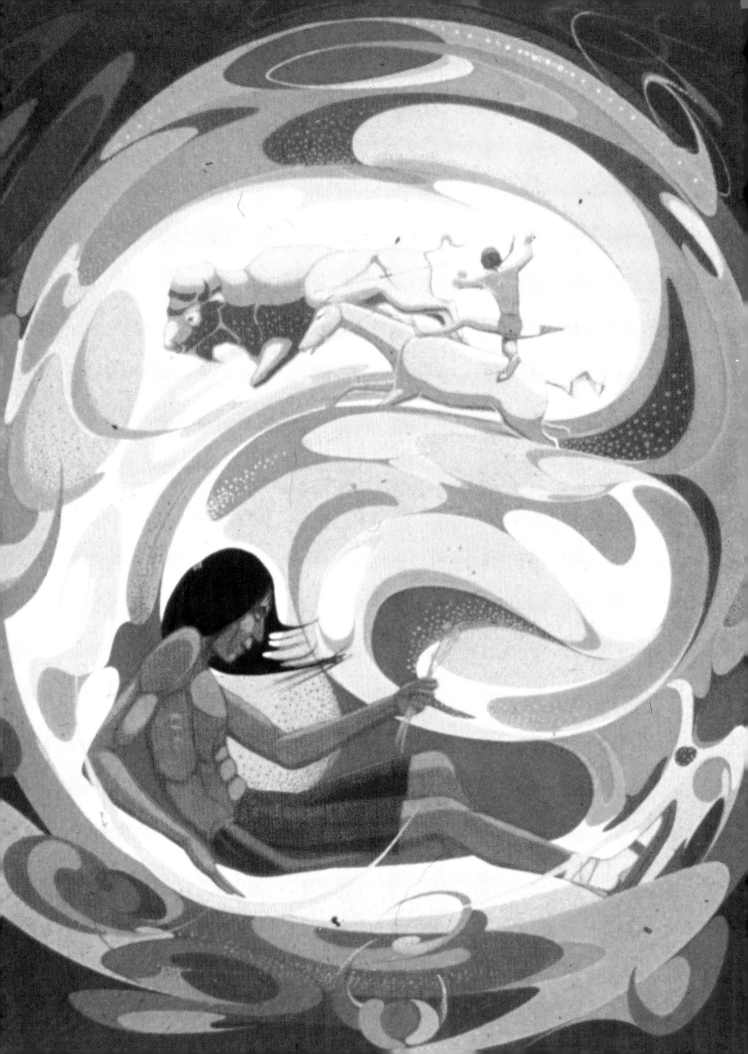

Chapter

1

The Arts of Native North America

About 500 years ago, the first Europeans sailed across the Atlantic Ocean and landed in North America. These explorers, and others that soon followed, were astounded by the vast continent, which previously no European had even known existed. They called it the "new world."

To the Native Americans who lived there, however, this land was hardly new. It had been the home of their ancestors for more than 10,000 years. In that time, Native Americans had learned to survive in many different regions of North America—from the freezing Arctic to the hot, dry lands of the Southwest. Across the continent, there were more than 350 tribes. Each group had its own customs and beliefs about the place of its people in the world.

News about Native Americans and their ways spread throughout Europe. Soon explorers were bringing home more than just stories. Their ships returned to European ports filled with treasures. Among them were gold jewelry, sculptures decorated with jewels, and clothing covered with

Opposite:
This painting of a Native American trickster, Onktomi, *was done by Oscar Howe, a well-known contemporary Native American artist.*

7

brilliantly colored feathers. Some were gifts from the Native Americans the explorers had met, but most of the items were taken by force.

The precious objects that Native American people created amazed the Europeans who saw them. Many agreed with Albrecht Dürer, a famous German artist, who in 1529 declared, "All the days of my life I have not seen anything that so gladdened my heart as these things did."

Art for Everyday

Europeans were not only impressed by the beauty of these items. They were also struck by Native American peoples' desire to decorate almost everything they made, including everyday clothing and tools. To Europeans, the idea of making such practical items into works of art was strange. Art to them meant paintings and sculptures, objects that were made primarily to be admired for their beauty.

Generally, Native Americans did not see the worth of making such useless things as paintings. Most objects they decorated were functional. A warrior might spend days painting his war shield in brilliant colors. However, he also made sure that his creation was strong enough to protect him from his enemies' arrows. A basket weaver might intertwine blades of dyed grass to make a detailed pattern. Yet she was careful to weave the grass tightly enough that her basket would be able to hold many pounds of nuts, berries, or even water.

In Europe, usually only people with many years of schooling were thought capable of creating works of art. Among Native Americans, however, decorating objects was such an important part of day-to-day life that just about everyone could be considered an artist. All Native American girls and boys learned to make common household goods by watching their elders. During these lessons, they were

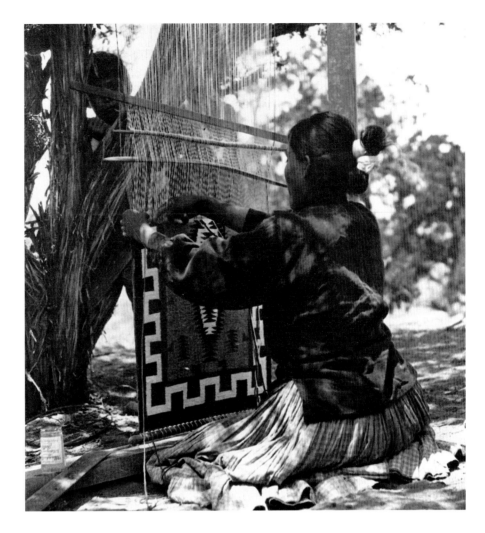

Native American artists created blankets with beautiful patterns.

taught to value objects that were easy to use, difficult to wear out, and attractive to look at.

Of course, there were some Native Americans in every tribe who had more artistic talent than others. A woman who painted tipis especially well or a man who carved bowls in particularly pleasing shapes was greatly admired by their neighbors. Their skills brought respect both to them and their families.

The time a tribe spent adorning its possessions also varied. Some devoted as much as half the year to creating art. Others barely found time to make the simple tools they needed to survive. The area where a tribe lived played a large part in determining how much art its people produced. In places where food was easy to obtain and the weather was mild, tribespeople were able to live comfortable lives with

little effort. These Native Americans had free time they could devote to creating art. In regions with few food sources and a harsh climate, people had to work much harder just to survive. After building shelter and finding enough food to last the day, they generally had little energy left for anything else.

Where a tribe lived also affected the types of objects it made. Native American artists found all of their supplies in nature, so they usually became most skilled at using materials that were available near their homes. Living within dense forests, tribes of the Northeast became talented wood carvers. In the Southeast and Southwest, where the earth is rich with clay, tribespeople developed many ways of making pottery. The people of the Great Plains shared their lands with great herds of buffalo. The hides of these animals became "canvases" for Plains artists to paint.

A wooden rattle, carved in the shape of a raven, was made by a member of the Haida tribe.

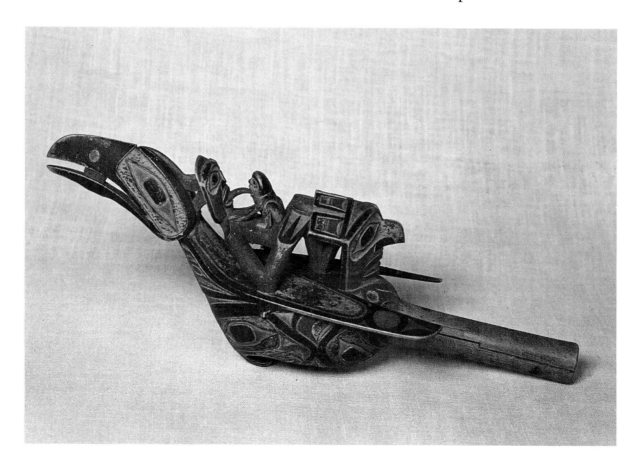

Another influence on Native American artists was tribal values. Each tribe had its own ideas about which objects and activities were important. For instance, tribes that were surrounded by enemies usually spent a great deal of time decorating the weapons and shields they needed for protection.

Religious beliefs also influenced Native American artists. Many decorated objects—masks, rattles, and drums—were used during religious ceremonies. Even designs and pictures on objects such as blankets, clothing, and pots usually had some special spiritual meaning.

These pictures often represented animals, plants, and other things found in nature. Most Native American religions taught their believers to respect and celebrate the creatures of the water, earth, and sky. Because they loved nature, many Native Americans did not try to draw or paint exactly what they saw. They believed that all creatures were already perfect, therefore to attempt to make an exact reproduction of one was foolish. The artists tried, instead, to use a painting to say something about an animal. A picture of a horse, for instance, might aim to make the viewer understand what a horse feels like when it runs.

Encountering Europeans

The first Europeans to see Native American art knew little about the ideas that inspired it. If a horse picture did not resemble a horse, they assumed the artist was unskilled. Most Europeans did not try to understand what Native Americans thought. Although they might be interested in the methods used by Native American artists, they judged Native American art by their standards and found it primitive. Frightened by these unfamiliar people, Europeans comforted themselves by assuming that they were superior to Native Americans. Some even believed that Native Americans were not human beings.

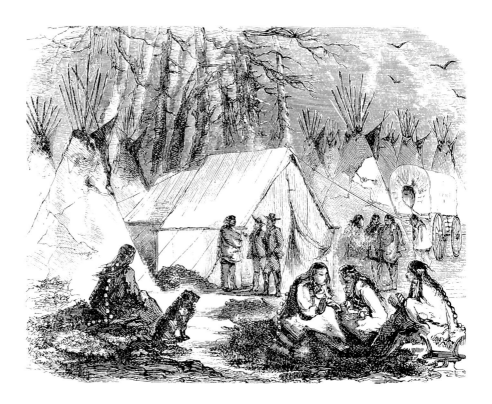

Native Americans and Europeans camped together to trade their wares. Often, Native American artists created new art forms with European goods.

Many Europeans wanted to acquire the lands of North America in the 1600s, and they began crossing the Atlantic in ever greater numbers. These European settlers believed that the fertile lands of North America were theirs for the taking. Most cared little that they were seizing control of territory where Native American people had lived for many thousands of years.

At first, most Native Americans welcomed these European settlers. Large areas in North America were then unoccupied, so it seemed as though there would be plenty of land for everyone. The Native Americans were also fascinated by the newcomers. They were particularly thrilled by the strange objects the Europeans brought with them from across the ocean. Native Americans had never seen iron axes and other tools made of this hard metal.

Soon Native Americans and Europeans began trading with one another. The Native Americans wanted European

manufactured goods. The Europeans wanted the furs of beavers, which Native Americans had long hunted in what is now the eastern United States and Canada. Beaver coats and hats were then very popular in Europe.

Through the fur trade, Native American artists were introduced to new art materials. European traders offered them buttons, metal, bells, and glass beads in an array of bright colors. These and other manufactured items excited the artists' imaginations. Adapting old crafts to use unfamiliar materials, they created many new art forms.

Unfortunately for Native Americans, the newcomers brought with them more than just trade goods. Many of the traders and settlers were also carriers of European diseases, such as smallpox and the measles. The Native Americans were not immune to these diseases. By the 1800s, these diseases had killed as much as half the Native American population in North America.

As more and more Europeans came to North America, they outnumbered the Native Americans up and down the continent's East Coast. Europeans seized control of the best lands, and forced Native American families living there to leave their homelands.

In the late 1700s, English settlers in the East formed the United States of America. Over the next century, the country took over millions of acres of Native American territory. Some tribes lost all their land. Others were sent to live on reservations, small tracts that were reserved by the U.S. government for use only by Native Americans.

The government also tried to force Native Americans to change their ways of life. Like the early European settlers, most Americans looked down on these people. Without taking the time to learn about Native American customs, they were convinced only through ignorance that their own way of life was superior.

✸

14

The U.S. government's systematic efforts to destroy Native American traditions and take over their lands had an enormous effect on tribal art. Many Native American adults were ordered not to teach their children how to make and decorate the objects that their people had valued for centuries. As a result, entire generations of Native Americans never learned to create these things.

At the same time, Native Americans began buying manufactured goods instead of making certain items themselves. Cotton dresses, shirts, and pants, for instance, could be purchased at cheap prices from European-owned trading posts. In the past, Native Americans had been proud to wear the decorated leather garments they made. However, as the government's campaign against Native American culture took hold, wearing such an outfit could get a person into trouble. Native Americans were sometimes arrested or even killed for observing their people's traditions.

By the late 1800s, most talented artists had stopped making artwork for themselves and their families. Instead, some began creating objects to sell to white people who visited their reservations as tourists. Reservation life was difficult for most Native Americans. Confined to tiny plots of poor-quality land, few reservation residents could make a decent living. Selling their wares to white people, therefore, offered Native American artists a welcome escape from poverty.

As many artists discovered, tourists did not want to buy the beautiful objects Native Americans had traditionally made and decorated. Most whites wanted cheap souvenirs rather than works of art, so Native Americans started to make objects that suited their customers' tastes rather than their own. In time, they, too, forgot the old ways. By the early 1900s, knowledge about some Native American art forms had been lost forever.

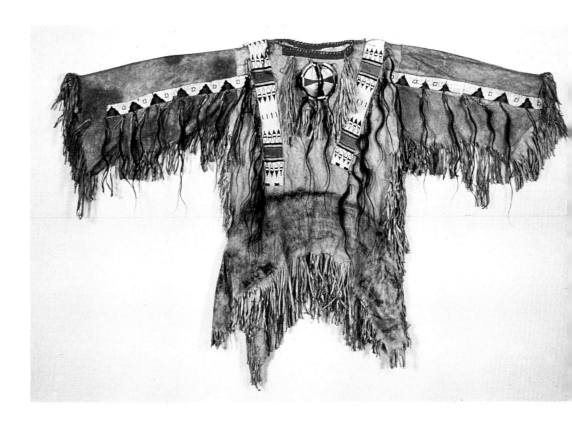

A man's buckskin shirt, decorated with paints and beads by a Dakota artist.

Combining the Old and New

Throughout this dark period, Native Americans created artwork for themselves and those close to them. Because of the prejudices of white people, Native Americans often felt they had to hide their creations from the view of others.

This situation suddenly changed in 1933, when John C. Collier was named the superintendent of Indian Affairs for the U.S. government. Collier respected Native American people and believed that the United States had treated them unfairly. He launched a series of innovative programs that were designed to help relieve the poverty of Native Americans who lived on reservations.

One program was the Indians Arts and Crafts Board. With funding from this organization, many Native American artists were able to revive crafts that were in danger of dying out. The board also set up a variety of exhibits and museums that introduced many white people to the rich artistic traditions of the native peoples of North America. The encouragement of white art collectors and museum-goers

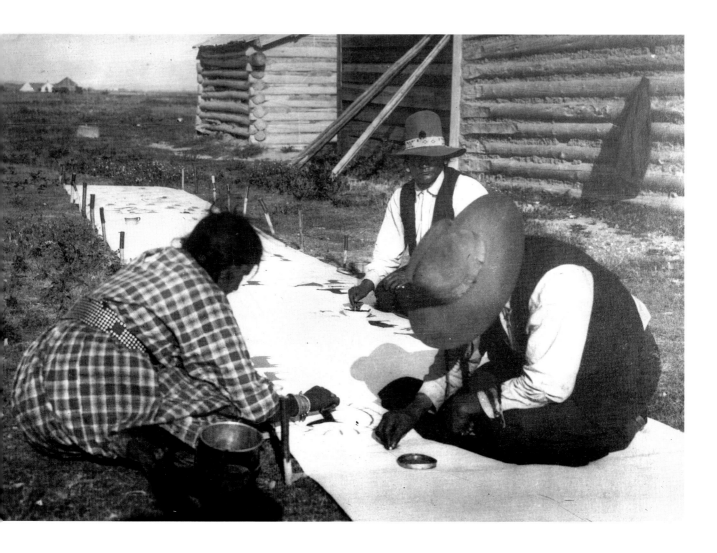

Members of the Blackfoot tribe paint their history on a large canvas.

inspired Native American artists to produce more and new types of art.

World War II (1939–45) also had an impact on Native American art. Serving in the U.S. military, many artists traveled to Europe for the first time. There they saw modern artwork being produced by young and daring European painters. When they returned home, some Native Americans began experimenting with these new European styles. One of the most successful was Oscar Howe, a Sioux, whose paintings of Native American legends remind many of the work of the famous Spanish artist Pablo Picasso.

During the following years, this mixture of styles and subjects flourished. By the late 1960s, many city-dwelling young Native Americans began standing up for the rights of tribal people. As part of this movement, they started studying the history and culture of their people. To the delight of Native American elders, many youths wanted to learn to make traditional crafts. The lessons of the elders helped revive Native American art forms.

Other Native Americans started taking art classes at reservation schools or cultural centers in major cities. The Institute of American Indian Arts (IAIA) in Santa Fe, New Mexico, also began training Native American artists. This school, which opened in 1962, taught its students both about Native American art traditions and the history of art in other areas of the world. According to Lloyd Kiva New, a Cherokee artist who served as one of its first directors, the school's varied lessons were designed to train young Native American students "to make up their minds as adults of the future how they will want to present their culture to the outside world." Many of the best-known artists of Native American descent, such as Oscar Howe, Allan Houser, and Fritz Scholder, received their education at this institute.

Until recently, most exhibits of Native American art showed historical works. To the dismay of living Native American artists, these shows seemed to say that their art was a thing of the past. Now, however, museums have begun displaying art created by contemporary Native Americans. In addition, the U.S. government is building a museum in Washington, D.C., that will feature Native American art of today and yesterday. Artists hope this will help non-Native Americans learn to appreciate Native American cultures. In the words of IAIA director Richard Hill, "Through the arts, people will get to see what Indians are saying, thinking. It's important for people to understand."

WALT DISNEY SCHOOL LIBRARY

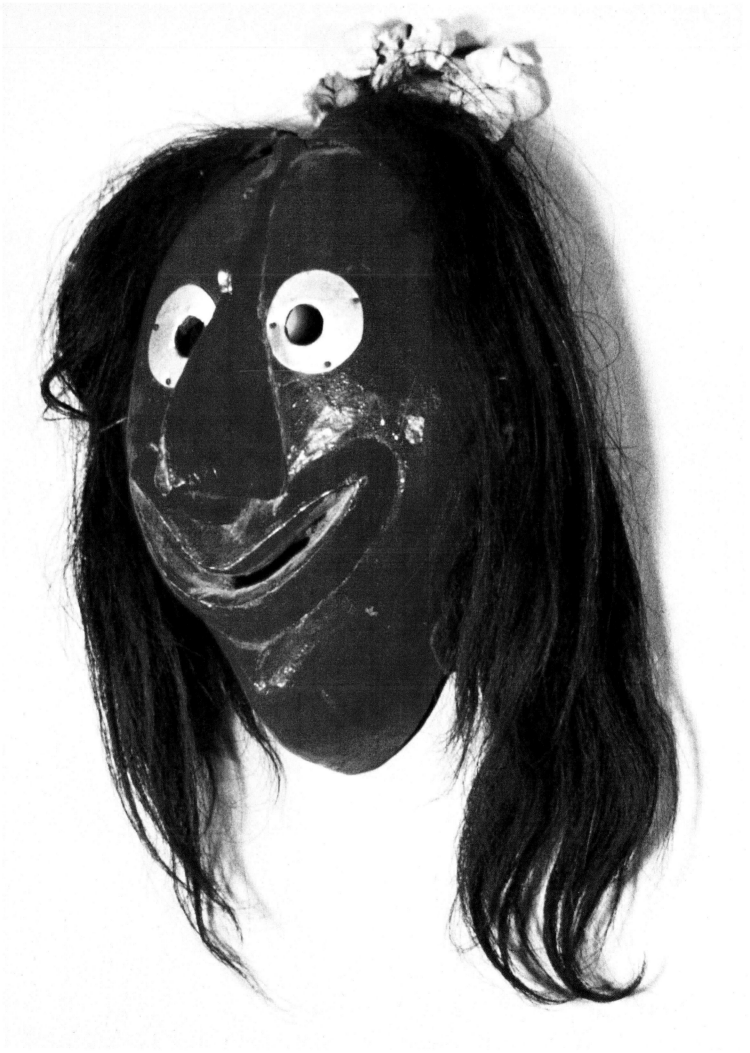

The East

The hundreds of tribes native to eastern North America held many different beliefs and practiced different customs. Yet they had much in common. Most of their lands were covered with grassy hills and woods. Through the forests flowed networks of rivers and streams. This environment offered many different kinds of food. Tribes of the Eastern Woodlands gathered nuts and berries and hunted deer, bear, and other animals of the forest. They fished in nearby waters. They also cleared small plots of land for planting corn, beans, or squash. These and other crops grew easily in the rich, well-watered lands of the East.

The languages of these tribes of the Eastern Woodlands were similar, so they could speak with members of other tribes. People from different tribes also got well acquainted because traveling through the region was fairly easy. The rivers in the East were like highways. In canoes, Native American traders could journey far distances. They often exchanged ideas as well as goods with other tribes. When

Opposite:
A False Face mask, called "Crooked Mouth," was made by an artist of the Seneca tribe. False Faces were used in special ceremonies by healers or medicine men.

the traders came home, they told what they had seen and learned on their travels. Sometimes, stories of the way another tribe built a house or trapped an animal encouraged the traders' friends and relatives to try new methods.

This means of sharing information was particularly important to Native American artists. Throughout the East, artists worked with the same materials—wood, stone, bone, and clay. News of how other peoples used these materials always caused excitement. Artists of one tribe were eager to experiment with the new types of art created by other tribes. As a result, in the Eastern Woodlands, Native American artists living hundreds of miles apart sometimes created artworks that looked very much alike.

The Mound Builders

Some of the oldest art produced by Native Americans was made more than 2,000 years ago. Many of these objects were buried with important people and probably had religious meaning. These artworks have been discovered in huge mounds of earth that served as graves.

Many of these items are made of stone, clay, shell, mica, or copper. Among them are effigies—sculptures in the shape of people or animals. Some combine the traits of different creatures. An effigy might, for instance, depict a man's body with an eagle's head or a snake with wings. In the Southeast, pots that look like human heads were particularly popular. These were possibly portraits of people who had recently died.

Some of the burial mounds themselves are works of effigy art. In what is now the state of Wisconsin are hundreds of effigy mounds of birds, bears, deer, and many other animals. Even more impressive is the Great Serpent Mound. Located in present-day Ohio, this grand sculpture of a snake is more than 500 feet long.

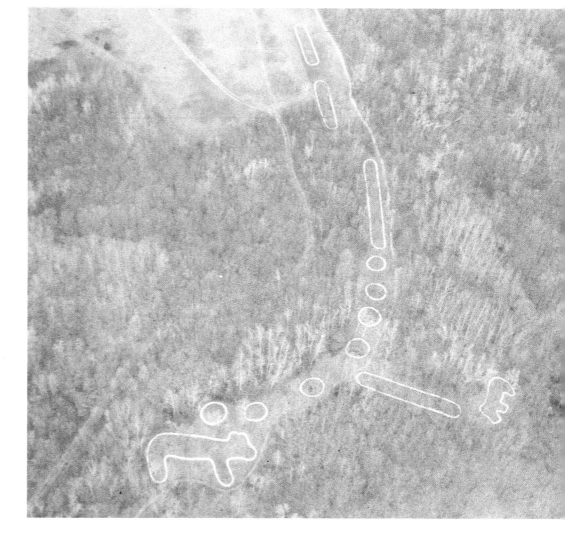

Great Bear effigy mound, located in Effigy Mounds National Monument, was created by Native Americans living in what is now Iowa.

Early Art of the Woodlands People

By the time Europeans came to North America, most eastern Native Americans lived in small villages. Just outside the village center were their fields and hunting grounds. Able to obtain food and shelter without traveling far from home, most tribes of the Eastern Woodlands were fairly settled people. Women worked hard to tend their gardens and gather wild plants, and men devoted much of their energy to hunting. Yet after their work was done, they still had time for creating arts and crafts.

✸

22

Like most Native Americans, the tribes living near the Great Lakes used their artistic talents to make objects for their religious ceremonies. Ojibwa (also called Chippewa) artists, for instance, carved pictures into sheets of bark from birch trees. These pictures were important to the Grand Medicine Society, or Medicine Lodge Society, a group of men and women who healed the ill. The ceremonies and medicine dances, called the *Midewiwin*, were very complicated rituals. The birchbark pictures of Ojibwa artists helped *Midewiwin* members remember how to perform each ritual.

Living in what is now New York State, the Iroquois used a different type of picture writing. They recorded important events with wampum—purple and white beads made from shells. By weaving strings of wampum into patterned belts, the Iroquois created a pictorial history of their people. They also presented wampum belts to other peoples with whom they signed treaties, or written agreements. Wampum was also frequently used as a form of currency, a practice started by European settlers in the 1600s to conduct transactions with Native Americans.

Another responsibility of Iroquois artists was making False Faces. These painted masks were worn by healers during special ceremonies. The features on False Faces were strange and exaggerated. Their mouths were twisted, their eyes bugged out, and their hair, made from horse tails in later times, stuck out wildly in all directions. Some of these masks were probably humorous portraits of the artists' friends and relatives.

False Faces were carved into the trunks of living trees. They were cut away from the tree only after the mask was finished. The Iroquois believed that masks made in this way retained part of the tree's spirit. In order to keep the False Faces "alive," the Iroquois sometimes fed them meals of tobacco.

Tobacco was smoked by tribespeople on special occasions. For this purpose, artists made pipes out of wood, stone, clay, and even copper obtained from early European settlers. They often decorated them with sculptures. Pipe bowls were sometimes shaped like human heads, and small crouching bears and other regional animals frequently sat on pipe stems.

Eastern artists also decorated their clothing. In the Northeast and Great Lakes region, the most popular decoration was quillwork, made with the sharp, spiky quills from the backs of porcupines. After collecting quills, the artists flattened, and then dyed them different colors and wove them into a pattern. Finally, the artists sewed the woven quills onto deerskin shirts and dresses to create colorful borders. Native Americans also used quills to embroider clothing. In this type of quillwork, the artist threaded a dyed quill in and out of the deerskin.

Many Native Americans also adorned their own bodies. Using vegetable dyes and colored clays for paints, and a pool of water for a mirror, they drew designs on their cheeks and foreheads. Face painting was a very common way of dressing up for a special occasion. Among some peoples, certain painted shapes were thought to protect the wearer from harm.

European Materials, Native American Inspiration

Eastern tribes were among the first Native American peoples to have contact with Europeans. At first, most of the whites in the East were explorers and traders. They introduced the tribes to new goods and their artists to new materials.

Artists particularly treasured the traders' glass beads. These beads were made in European workshops and came in

A woman's ribbonwork robe was made by an artist from the Sauk-Fox tribe.

many colors. Some Native Americans began decorating their clothing with beadwork. These artists soon found that beads were easier to handle than porcupine quills. They could also be sewn in more complicated patterns. With stiff quills, artists could make only simple squares and triangles. With beads, they could represent curving flowers and leaves.

The Huron people of present-day Canada were particularly skilled at creating flowered patterns. They learned how to make these designs from French nuns. These women came to the Huron's territory with priests in the late 1600s to convert the Native Americans to Christianity. From France, the nuns brought needles and thread, which they taught the Huron to use. When their supply of thread ran out, the Huron discovered they could embroider with moose hair. Combining North American materials and European designs, they created an all-new art form.

Native American artists in many parts of the East were inspired by European fabrics. They started sewing panels out of silk or cotton ribbons. Like woven quillwork, these panels were sewn into clothing and blankets. In the mid-1900s, the Seminole tribe of Florida took ribbonwork a step

further. Using a sewing machine, they began creating clothing entirely out of ribbons. Their brilliantly colored striped shirts are unlike those made by any other tribe.

Adapting to Life Among Europeans

As more Europeans arrived in the East, Native Americans lost control of their lands. This shift was gradual, and, over time, some eastern tribes, especially the Iroquois, found ways of coexisting with non-Native Americans.

Most of the Southeast tribes, however, were not as fortunate. The largest southeastern tribes, such as the Cherokee and the Creek, were forced out of their homelands in the 1830s and the 1840s. These tribes were able to remake their communities in what is now Oklahoma, but the move disrupted tribal life. Still, a few old southeastern crafts have survived. Cherokee women continue to weave baskets from split cane, and the Creek are well known for their distinctive pottery.

In the Northeast and the Great Lakes region, many traditional arts are alive and thriving. The Iroquois, in particular, have been able to observe old ways while living fully in the contemporary world. Many of their artists have also embraced other methods of making art. The stone-carved sculptures of Mohawk Stan Hill and Tuscarora Duffy Wilson, for instance, combine new forms with subjects from Iroquois history.

Similarly, the traditions of the *Midewiwin* remain strong among the Ojibwa and continue to inspire these artists. Greatly admired is Norval Morrisseau, one of the most popular painters in Canada. In the late 1970s, he began painting images from the *Midewiwin's* birchbark scrolls on canvas. Breaking tradition by sharing these sacred images with the public, Morrisseau's work represents a bridge between the past and the present.

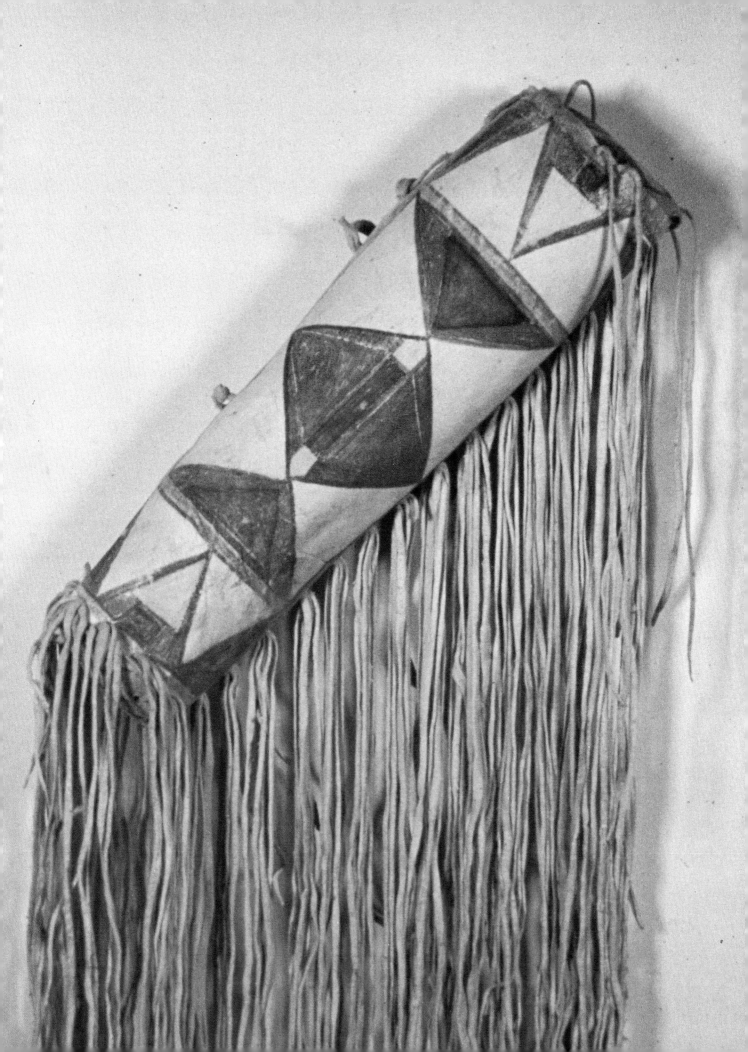

Chapter

3

The Great Plains

In the center of what is now the United States is a huge stretch of flat, grass-covered land. This area is known as the Great Plains. Native Americans first arrived in this region about 10,000 years ago. These early inhabitants were hunters and gatherers, but as time passed they learned to farm. By the 1700s, most Plains tribes lived in small villages. In the lands near their homes, they grew crops and searched for wild plants to add to their diet.

The lives of these settled farmers suddenly changed in about 1750. At that time, Native Americans living to the south introduced them to a new and wonderful trade good—the horse. The Plains tribes had never seen this animal before. Horses had been brought to North America by Spanish explorers only about 200 years before.

Almost immediately, the Native Americans of the plains realized how horses could make their lives easier. Previously, the only way they could move from place to place was on foot. Traveling even short distances took a great deal of

Opposite:
A Crow parfleche, or travel bag, was used for transporting warbonnets.

27

time and effort. Mounted on horses, however, Plains tribal members could ride more than a hundred miles in just one day. To a people used to staying very close to their homes, racing across the plains on horseback was a new and exciting adventure.

As they acquired more horses, Plains people began spending less time raising crops. Farming was hard work, and, in a year of bad weather, fields might yield small harvests despite a farmer's best efforts. They found they much preferred life as hunters. Riding on horses, they could follow the herds of buffalo that roamed the plains. A well-trained horse could get so close to a buffalo that its rider could easily kill the large animal with a bow and arrow.

Life as Buffalo Hunters

One buffalo provided plenty of meat for a hunter and his family. However, Plains people got much more than just food from these animals. They developed a use for almost every part of the buffalo.

Aside from its meat, probably the most important portion of a buffalo was its skin, or hide, which was made into leather by the women of the tribe. After a buffalo was skinned, a woman rubbed the hide with a paste made from the animal's brains and liver and soaked it in water for several days. She then placed it on the ground and used stakes to stretch it tight. When the hide dried, the woman had a large piece of leather out of which she could make clothing, shoes, travel bags (parfleches), or even portable, cone-shaped houses known as tipis. Tipis were made by placing a leather cover over a frame of poles. Because they could be easily put up and taken down, tipis became the favored type of dwelling for the Plains people.

Constantly on the move, Plains people did not own many possessions. Those they had were decorated in

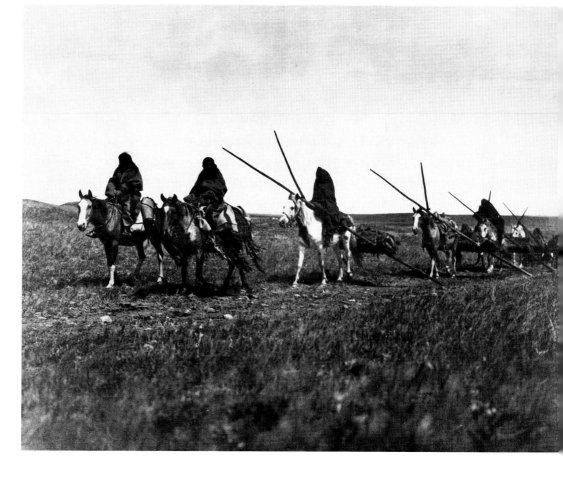

Horses and travois (a platform, supported by poles, which was dragged by a horse or dog) were used to move a Plains tribe to their next campsite.

elaborate ways. Plains artists adorned their clothing with quillwork. They learned this craft from northeastern tribes that had moved to the plains centuries before.

Many Plains artists were also talented painters of leather. First, they outlined a pattern by scratching a piece of clothing or a tipi cover with a bone tool. They then rubbed dyes made from vegetables or crushed rocks into the scratch marks and the areas within them.

Dyes were also made from fine clays containing different colored oxides of iron that were mixed with buffalo tallow (animal fat). The yellow substance in the buffalo's gall bladder was valued as a medicine paint. The paint was applied with the fingers and sometimes with brushes made

Mato-Tope: Mandan Painter

In the early 1800s, the Mandan tribe became well known among non-Native Americans as a tribe that was friendly to visitors. In 1804, they welcomed the American explorers Meriwether Lewis and William Clark to spend the cold winter in their homeland, in present-day North Dakota. Clark told many tales of their hospitality to his friend George Catlin, who was a skilled painter. With Clark's encouragement, Catlin decided to travel through the plains and meet the Native Americans living there.

Catlin arrived in Mandan territory in 1832. During his visit, he became acquainted with a young man named Mato-Tope. Mato-Tope was the second chief of the Mandan, but Catlin was more impressed by his artistic skill than by his title. Like Catlin, the Mandan leader was an accomplished painter, but unlike his new friend, he painted on buffalo hides rather than on cloth canvas. The two showed one another their work. From Mato-Tope's art, Catlin learned something of how Native Americans saw their world. From Catlin's paintings, Mato-Tope discovered new ways of painting and drawing.

When Catlin left the Mandan to continue his travels through the plains, he paid tribute to Mato-Tope by painting his portrait. Catlin's work shows the chief standing tall and proud, wearing a painted buffalo-skin robe and a feathered headdress that reaches all the way to the ground.

Two years later, the Mandan played host to Karl Bodmer, an artist from Switzerland. When he met Mato-Tope, Bodmer also asked the Native American to pose for him. The painting is now considered one of Bodmer's best portraits.

Mato-Tope was as talented a warrior as an artist. In recognition of his war exploits, Mato-Tope was named the principal chief of his people in 1837. The same year, an outbreak of smallpox—a European disease that was probably carried by some of the travelers the Mandan welcomed—swept through their villages. Most of the Mandan died during the epidemic, including Mato-Tope. Among those who survived, he was remembered as an important leader. Today, he is considered both the creator and subject of some of the greatest paintings of his time.

from sticks. Plains Indians used a spongy bone from the knee joint of the buffalo to hold paint in much the same way a common fountain pen holds ink today. Men often painted their faces and bodies to be admired or to create fear in an enemy. Red was often a favorite color for painting the face and body. It was often used for dance and battle and for painting the war pony, lance, and other articles of war and ceremony.

Women's paintings were usually designs from simple shapes, such as triangles and squares. Men's paintings were often pictures that told a story about their accomplishments in battle. These paintings were like advertisements that reminded a man's neighbors about his talent as a warrior. Because Plains tribes often fought one another for the best territory in the region, a man who was known to be a skilled fighter was sure to earn the respect of his tribespeople.

Some Plains tribes, such as the Sioux, also used paintings to note important events that happened each year. These "calendars" were called winter counts. Like most Native American tribes, the Sioux did not have a written language. Winter counts, therefore, were their means of recording the history of their people.

Fighting for the Homeland

In the early 1800s, non-Native Americans began to travel to the Great Plains for the first time. Among the first to arrive were artists, such as George Catlin and Karl Bodmer. These painters were interested in Native American people and their customs. They wanted to meet the Native Americans of the plains and use paintings of them to show non-Native Americans in the East how these tribes lived. Watching these artists work, some Plains Indians learned to paint in new ways with new materials. They were especially fond of the factory-made paints, which produced brighter colors and

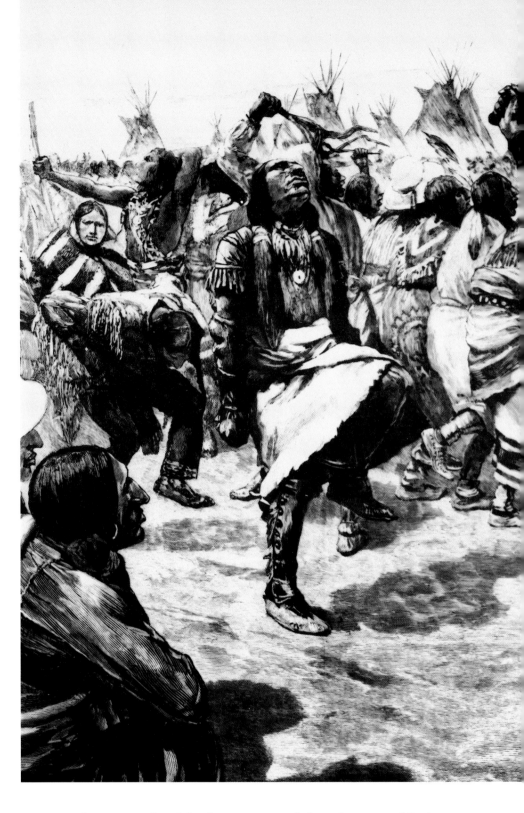

Members of the Sioux tribe perform the Ghost Dance to protest the taking of their tribal lands. Tribal artists decorated the dancers' clothing with symbols of their past.

were easier to work with than many of the pigments Native Americans made themselves.

At about the same time, Plains artists came in contact with non-Native American traders, from whom they obtained glass beads. Like tribes in the East, many began using beadwork in place of quillwork.

32

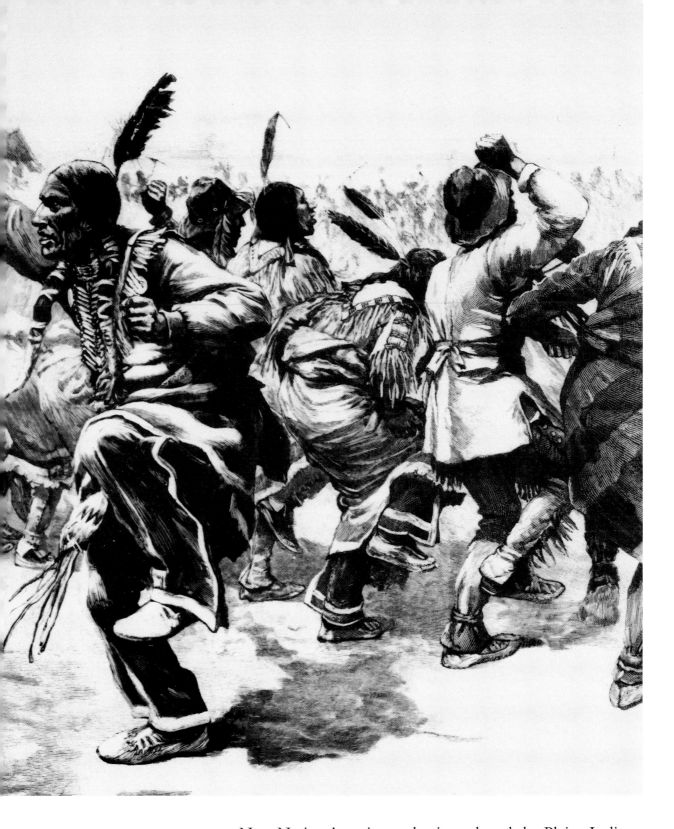

Non-Native Americans also introduced the Plains Indians to woven cloth. In the mid-1800s, some Native Americans began wearing clothing of American-made cotton rather than of buffalo skins. The Sioux also started making winter coats from muslin, a rough fabric that was easier to paint than hide.

Some of the white people on the plains were American soldiers. They gave Native American artists ledger books, used by the army for record keeping. These artists were excited by the books' blank paper pages. Using pencils and crayons they obtained from the soldiers, they began sketching on paper for the first time.

In ledger drawings, the Plains Indians made their own records about their lives and the changes they were experiencing. In the late 1800s, the U.S. government decided to take control of the Great Plains, so that its citizens could move there and establish farms and homesteads. Fiercely proud of their talents as warriors, the Plains Indians refused to give up their lands without a fight. For more than twenty years, American soldiers and Plains warriors fought. Outnumbered by the non-Native American newcomers, the Plains Indians were defeated in the end.

Despite their victory, the Americans still feared the Plains Indians. They moved the tribes to reservations, where they could keep track of their every activity. To people who loved the freedom of traveling across the plains, these reservations felt like prisons.

The U.S. government made actual prisoners out of some of the tribal leaders. These Native Americans were sent to jail at Fort Marion in Florida. There, many sketched drawings on paper that told of their miseries in jail and their joyful memories of life on the plains.

On the reservations, some Plains Indians demonstrated their anguish by performing the Ghost Dance. The Ghost Dance religion started around 1888 and taught that one day all white people would disappear and the ghosts of the Native Americans' dead relatives would return to Earth. The dance offered artists an outlet for their creativity. They decorated the dancers' shirts with symbols that had adorned Native American war shields. Alarmed by the message of

the Ghost Dance, the U.S. government began punishing anyone who performed it. The famous Sioux leader Sitting Bull was killed on December 15, 1890, in part because of his support for the dancers. He was the leader of the Ghost Dance religion. The dance is still performed today.

New Art on the Plains

As the Ghost Dance was suppressed, many Native Americans on reservations sank into despair. Some Plains Indians stopped creating art and teaching their children about traditional crafts. A few craftspeople, however, were careful to pass on their knowledge to the next generation.

The early 1900s even saw the revival of one important Plains tradition. From tipi covers to ledger drawings, Plains artists were long accustomed to using their art to tell a story. In the 1920s, the drawings of a group of young Kiowa artists were brought to the attention of the director of the School of Art at the University of Oklahoma. Recognizing their talents, he helped ensure that they were accepted to the university and received formal training. Known as the Kiowa Six, these artists were among the first to use non-Native American painting techniques to depict their culture and history. Inspired in part by their example, the later generations of Plains artists have embraced painting on canvas with enthusiasm.

Another outlet for the creativity of Plains Indians are powwows. These celebrations are attended by Native Americans, as well as other guests. They usually feature performances of Native American singing and dancing. The participants wear elaborate headdresses and costumes, most often covered with feathers and beadwork. Although these outfits are far more showy than garments worn in the past, the powwow dancers display the same high spirits and energy that made their ancestors the masters of the plains.

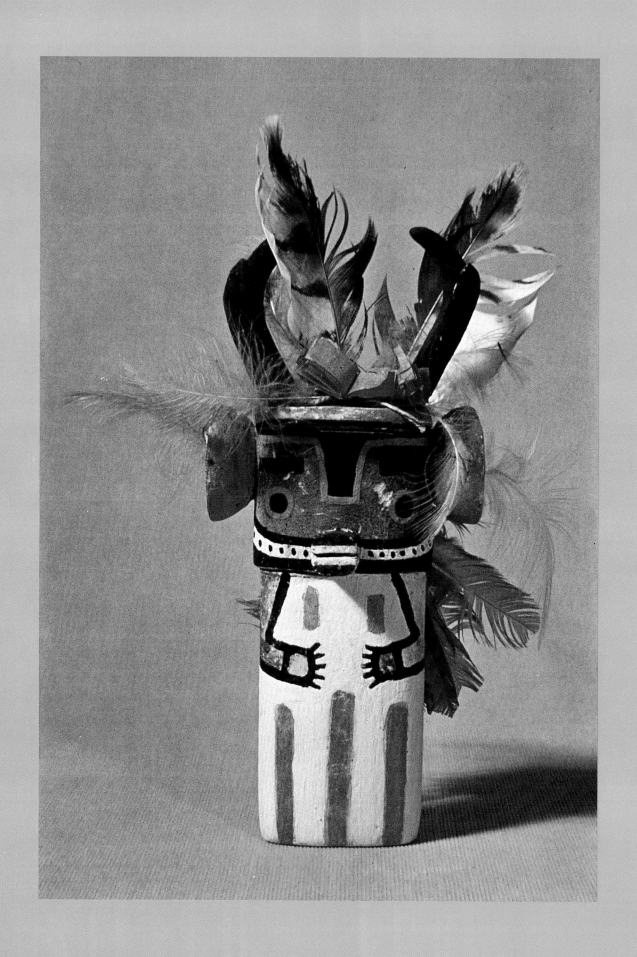

Chapter

4

The Southwest

Out of all the regions of North America, the Southwest has possibly the harshest environment. The air is dry, and the sun's heat is intense. With little water to provide relief, few animals or plants are hardy enough to live in the area.

For the Southwest's first Native American inhabitants, survival was a constant challenge. Even as early as 10,000 years ago, southwestern Native Americans had developed ways of thriving in their desert environment. Through fierce persistence and ingenious irrigation systems, they gradually learned to grow corn in this region. Their farming methods, which made good use of every drop of water, were more advanced and efficient than those used almost anywhere else in the world at the time.

Another aid in the southwestern tribes' struggle to stay alive was the close-knit nature of their communities. Developing tight bonds with one another helped people feel protected. The Native Americans also drew comfort from their religious beliefs, which taught them to seek balance in their lives and to face difficulties with calmness.

Opposite:
This Hopi kachina doll was made by the artist to represent the spirit of an antelope.

Art in the Ancient Southwest

Much of the greatest art produced by ancient Native American peoples was made in the Southwest. Some of the most talented artists were the Hohokam, the Mogollon, and the Anasazi. These peoples produced beautiful pottery, basketry, and weavings. The Anasazi also painted murals on the clay walls of their houses.

The hot, dry weather of the region has helped to keep the pottery of these cultures from crumbling. These peoples' descendants, therefore, were able to copy the designs and decoration techniques used by artists who lived thousands of years before.

The arts of the Anasazi, for instance, were handed down to the Pueblo people. These Native Americans are so-named because they live in clay-brick houses now known as pueblos. The Pueblo tribes include the Zuni, the Hopi, and the Acoma.

The Laguna Pueblo in New Mexico consists of homes made of clay-brick.

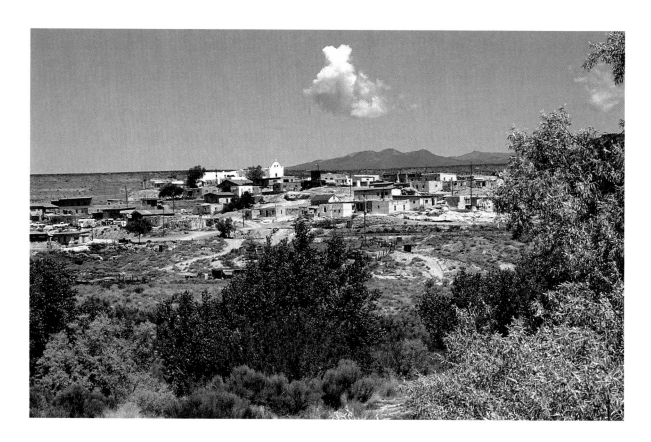

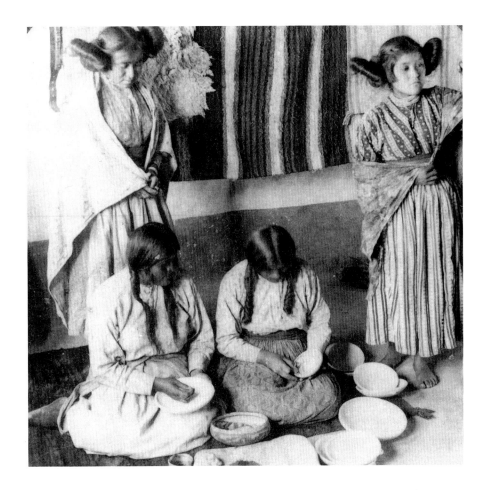

Women artists from the Hopi tribe decorate clay bowls on the Hopi Reservation in Arizona in 1903.

Pueblo artists created pots for day-to-day use, such as carrying water or food, and for ceremonies. The ceremonial pots usually had the most detailed decorations. The Pueblo painted the off-white clay with black and red dyes. Using just these two colors, they created amazingly inventive patterns and animal shapes.

The Pueblo were also excellent weavers. They taught this skill to their neighbors, the Navajo, who, along with the Apache, came to the Southwest from the north during the 1400s or 1500s. Soon the Navajo were making even better weavings than their teachers.

At first, the Navajo wove cloth from cotton grown by the Pueblo. In time, they started using the wool from sheep instead. These animals were introduced to North America by Spanish explorers and settlers. The Navajo began keeping their own sheep herds, and the animals became for them an important source of food as well as of weaving material.

Western Tribal Arts

As the Navajo and Apache were adapting to the Southwest, many other tribes were producing artwork to the north and west in what is now California, Utah, Nevada, and Montana. Their earliest masterpieces were works of rock art. Some were produced by scratching pictures (petroglyphs) into the surface of large rocks. Others were made by applying vegetable paints of several colors to rock faces (pictographs). In some areas, where this artwork has survived, national monuments have been established to preserve the culture.

Many California tribes were also extremely skilled basketmakers. Tribes such as the Chumash, Yokut, and

Symbols and pictures, called petroglyphs, were scratched into rocks by many ancient Native American artists. These petroglyphs are protected at the Dinosaur National Monument in Utah.

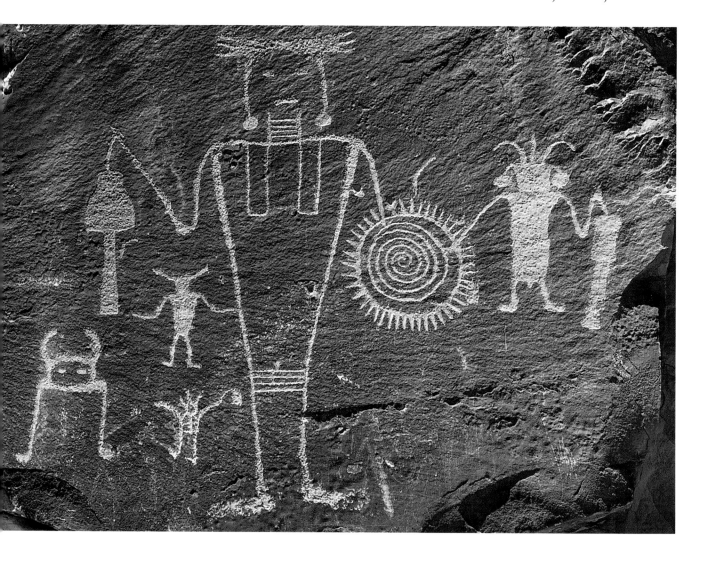

Hupa created delicate baskets with complicated dark-and-light patterns. The most spectacular basketmakers of the region were the Pomo, who liked to weave bird feathers, shells, and many other ornaments into their creations. The Pomo were so skilled that they could make beautiful baskets as large as four feet wide or as small as a human thumbnail.

The arrival of non-Native Americans in California, beginning in the 1500s, disrupted the lives of the native people more quickly and more completely than almost anywhere else in North America. In many tribes, diseases that were carried by Spanish explorers killed nine out of every ten people. Many descendants of those who survived were later killed by miners, who came to the region looking for gold in the 1840s.

Making Art for Tourists

The Navajo people also suffered at the hands of non-Native Americans until the 1860s. In this decade, the United States took over the Navajo homeland. The tribe was placed on a reservation in what is now Arizona and New Mexico. Soon after, American tourists from the East began traveling to the Navajo reservation. The vacationers were attracted to the Southwest by its landscape, which featured many beautiful canyons and majestic mountains.

Once there, tourists were also drawn to the beautiful blankets and rugs made by Navajo women. They often bought these goods and brought them home. When the weavings were seen by other Easterners, the market for Navajo rugs grew. American traders soon started buying up the Navajo's works and reselling them to Easterners for a profit. Some traders asked the weavers to make their rugs in a certain way, knowing that some designs sold better than others. Most tried to persuade the Navajo to stain their wool with the same vegetable dyes their ancestors had used.

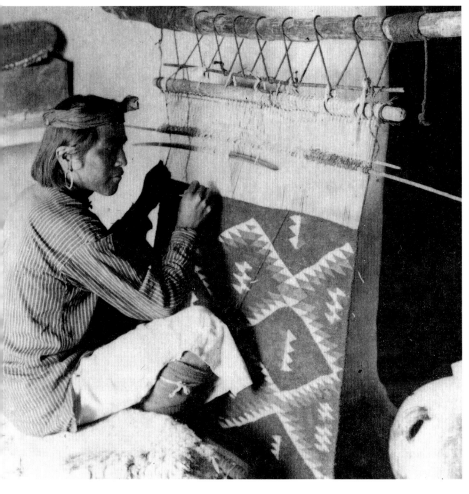

A Hopi weaver works on a blanket in Wolpi, Arizona, in 1903.

To the non-Native Americans, the dull colors these dyes produced were more authentic. For their own rugs, the Navajo preferred the bright hues of the factory-made dyes obtained from the traders.

Traders also encouraged Navajo men to become silversmiths. Beginning in 1853, these traders brought Mexican silversmiths to the tribe to teach this craft. Like Navajo weavers, these students quickly became more skillful than their teachers. They learned to make lovely necklaces and pins, many decorated with turquoise stones from Mexico. Almost immediately, Navajo silverwork became popular with tourists.

In the mid-1900s, the Navajo and the Pueblo began to sell still other traditional crafts, such as dry paintings and kachina dolls. Following the example of their Pueblo neighbors, the Navajo had learned to make dry paintings, also called sand paintings, soon after moving south. These images were created from crushed rocks of several different colors. Originally, dry paintings were made during ceremonies to help cure the ill. A healer carefully spread out the crumbled minerals to create a picture that represented one of the ancient stories of the tribe. When the ceremony was over, the dry painting was always destroyed. The Navajo saw that tourists were fascinated by these images, so they began making permanent versions by gluing the crushed

rocks onto wooden boards. Some artists also started paint-ing the images from dry paintings on canvas. Unlike those used in ceremonies, these modern dry paintings have no religious meaning.

Kachina dolls have long been made by the Pueblo. According to their religion, the kachinas are spirit beings that usually help, but sometimes harm, humankind. The kachina spirits also bring rain. Pueblo parents gave their children little painted wooden dolls in the shape of the various kachinas as a way of teaching them about these important spirits. As tourists began to buy and collect the dolls, Pueblo craftspeople started making some just for sale. These statues were usually more brightly colored and more heavily decorated than those made for their own daughters and sons.

Creating Art for Two Cultures

In the early 1900s, the Navajo and Pueblo took up a new art form—painting on canvas in the style of non-Native Americans. At that time, white scholars came to the South-west to study Native American cultures. These scholars asked some of the best tribal artists to use paintings to record information about their ceremonies and histories.

Some of these painters received formal training at The Studio, the first art school for Native Americans. Founded in 1933, it was part of the Santa Fe Indian School on the lands of the San Ildefonso Pueblo. Many of The Studio's graduates became well known in the art world. Among the most successful were Navajo painters Harrison Begay and Andrew Tsinajinnie.

Most artists trained at The Studio painted pictures of Native American life of the past. In the 1960s, many younger southwestern Native American painters rebelled against this style. They wanted to create works that depicted

Maria Martinez: San Ildefonso Pueblo Potter

When Maria Montoya was a young girl living on the San Ildefonso Pueblo, she learned from her aunt how to make pottery. She was taught that her people decorated their tan-colored pots with designs painted in red and black. With time and practice, Maria became a talented potter and painter.

A few years after her marriage to Pueblo farmer Julian Martinez in 1904, Maria met a scientist who was studying the ruins of ancient Native American villages in the Southwest. He showed her the pieces of a pot he had found buried in the earth. The pot was jet black and had a glossy, almost silvery, sheen. It was unlike any piece of pottery Maria had ever seen.

Maria Martinez was fascinated by the scientist's discovery. She became determined to discover how her ancient ancestors had created such a pot. Together with Julian, she experimented with different ways of treating clay. Through trial and error, she discovered that if she polished a pot with a smooth stone and fired it so that it was exposed to a great deal of smoke, she could make shiny black pottery of her own.

More interested in art than in his fields, Julian took a job as a janitor at the Museum of New Mexico in Santa Fe. There, he and his wife studied the southwestern pottery in its storerooms. Inspired by what they saw, Maria Martinez developed a way of painting certain areas on her black pots so that even after they were fired, these spots had a dull finish. These black-on-black designs became her trademark.

Homesick for the San Ildefonso Pueblo, Maria and Julian Martinez moved back in 1921. There she taught other potters about the painting and firing methods she had discovered. Encouraged by friends, Maria Martinez also began signing her works. Exhibits of Martinez pottery eventually made her well known in art circles in the United States and abroad. They also earned her honorary degrees from the University of Colorado and New Mexico State University. Before her death in 1980, Maria Martinez had become the most famous Native American artist in the world.

Ever eager to share her knowledge, Martinez ensured that her art form would survive. Today many fine potters in San Ildefonso still produce pottery in the distinguished Martinez tradition.

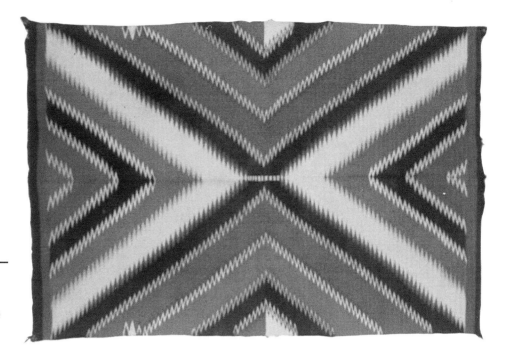

A colorful saddle blanket, created by a Navajo artist in New Mexico.

how all people lived in the modern world. Many of these artists, such as Fritz Scholder and T.C. Cannon, explored new subjects and different styles while studying at the Institute of American Indian Arts. Although proud of their heritage, this generation of artists does not want collectors to buy their works only because they are Native Americans. They want to be well known and respected because they are excellent painters.

In the Southwest today, modern painters and reservation craftspeople alike are taking more control over the marketing of their work. In the past, white traders pocketed most of the profits from southwestern Native American artwork. Today, many Native American artists sell their own work through their own cultural centers, galleries, and art fairs. The largest fair, the Santa Fe Indian Market, attracts more than 70,000 visitors every year. As the demand for their work grows, many southwestern Native American artists are finding it easier to make a living by doing what they love best.

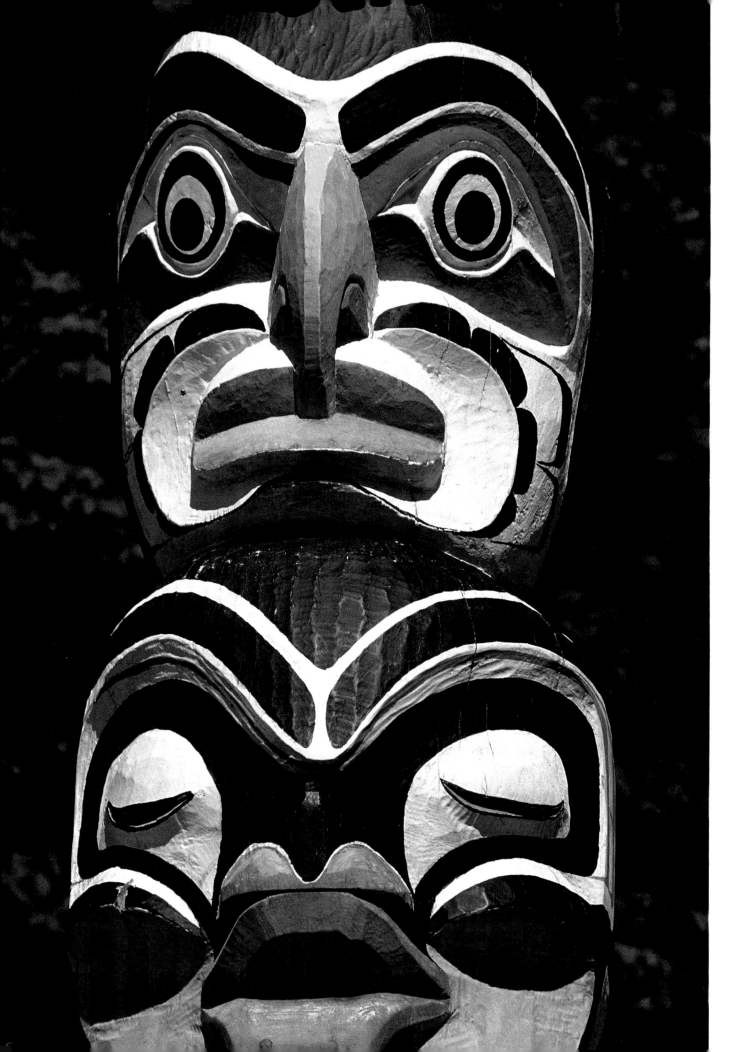

5

The Northwest

Perhaps the most beautiful area of North America is the Northwest Coast. This strip of land lies alongside the Pacific Ocean and stretches from southern Alaska to northern California. Warm ocean currents keep the weather in the region pleasant year-round. In the moderate climate, both plants and animals thrive. Covering the Northwest's hills and mountains is a blanket of fir, spruce, and cedar trees. These forests provide a comfortable world for animals, including deer, elk, goats, and bears.

This area was extremely hospitable to its first human inhabitants more than 10,000 years ago. The early Native Americans who called the Northwest their home led relatively carefree lives. Unlike Native Americans who lived in harsher environments, they never had to worry about having enough food to eat. They could always hunt game animals or gather the nuts and berries that grew wild in the wooded regions near the coast. With even less effort, these Native Americans could make a delicious meal from the animals of

Opposite:
Dramatic faces
are carved into a
beautiful totem pole in
Vancouver, British
Columbia.

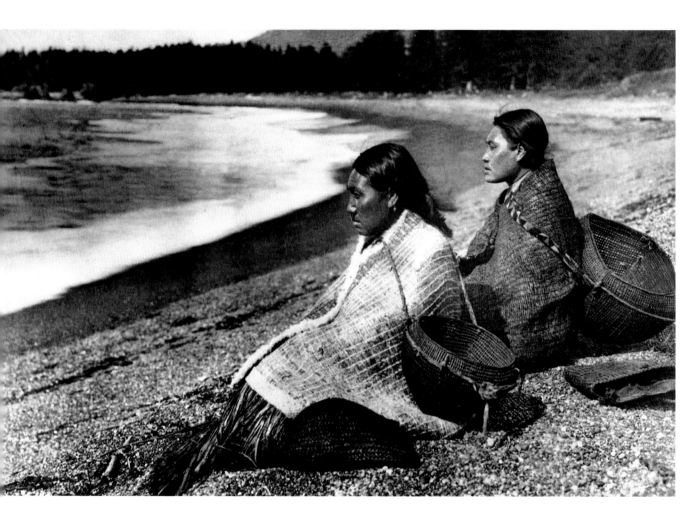

Baskets created by Native American artists of the Northwest have traditionally been used to collect shellfish.

the sea. Women collected shellfish buried in the sand along the beach and offshore. Men fished in the ocean and in the many rivers that ran through their lands.

To help them take advantage of the ocean's and rivers' bounty, the Northwest Coast tribes created many different types of fishing nets and hooks. Just as important were their canoes, which skilled carvers made from tree trunks. Some of these canoes were large enough to hold fifty people. As they worked, both women and men often wore hats woven from grasses that were native to the area. Somewhat like upside-down baskets, these hats shielded them from the Northwest's frequent downpours.

Yet, the most important inventions of the Northwest Native Americans were their various methods for preserving fish. During the late spring and early summer, their rivers and streams were full of thousands of salmon that were swimming upstream to spawn. Northwest Coast Native Americans caught as many of these delicious fish as they could. Some salmon were eaten fresh, but many were dried and stored. By the time winter set in, the storehouses were full enough to last for months.

Celebrating the Animal Spirits

The wintertime offered the Northwest Coast tribes a long vacation from the work of finding food. Yet, throughout the season, they remained busy, preparing for, and performing, religious ceremonies. With these winter ceremonials, they showed their respect for the spirits of animals. Many Northwest Coast Native Americans believed these animal spirits were very powerful and would cause them harm if they were not honored with special dances.

Northwest Coast artists played a crucial role in the ceremonials. They made the elaborate costumes worn by the dancers, including huge masks, which were carved and painted to represent different spirits. In the ceremonies, the dancers often acted out stories of animal spirits and their magical powers.

In many of these stories, one animal spirit changed into another. To aid the dancers' performances, artists often created masks with moving parts. For instance, a performer might have begun his dance wearing a bird's-head mask. Then suddenly, by pulling a hidden string, he could make the bird's beak fly open to reveal a carved human face behind it. Artists tried to make masks that would move in such unexpected ways that they would scare or shock the people watching the performance. In this way, the artists

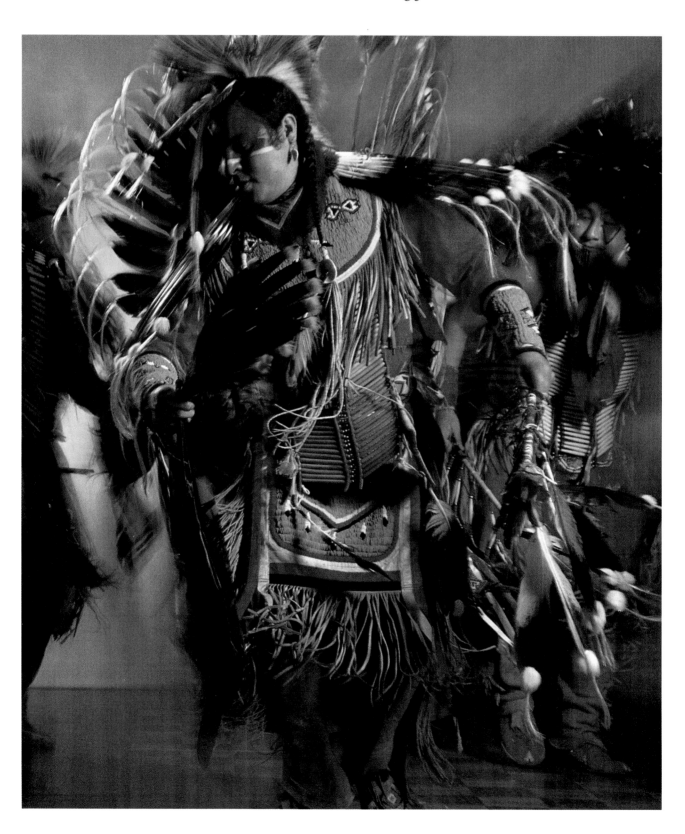

were like the filmmakers of today who try to surprise movie audiences with special effects.

Northwest Native American artists also showed respect to the spirits by creating totem poles. Made from tree trunks, totem poles were covered with carved images. Each image pictured a different event in one of the stories of animal spirits.

Skilled carvers were hired by wealthy families to create special totem poles to place in front of their houses. Every important family believed it had descended from an animal spirit. A totem pole displaying carvings of its animal ancestor was a way of advertising to everyone in the village that the family was powerful and deserved respect.

The Potlatch

Another way of earning the respect of others was by hosting a potlatch. A potlatch was a great feast that was held among the Tlingit, Kwakiutl, and other Northwest Coast tribes to celebrate an important event, such as a marriage or the birth of a child. The potlatch hosts invited all their friends and relatives to their home. When the guests arrived, they were offered a huge array of food, served with wooden bowls and spoons that were often decorated with carved animal or human faces. The host family tried to impress its guests by presenting the biggest and best feast possible. An impressive potlatch told the community that its hosts were wealthy and powerful people.

Even more important than the food offered at a potlatch were the gifts the hosts gave their guests. To show off their wealth, hosts gave away beautiful objects made by the most talented artists. These gifts often included fur or goat's-wool robes, cedar-bark mats, and canoes.

Among the most popular potlatch gifts were blankets. The Northwest Coast Native Americans made blankets from

Opposite:
A Native American dancer performs the Hamatsa Dance of the Kwakiutl tribe. This dance teaches youths civic duty.

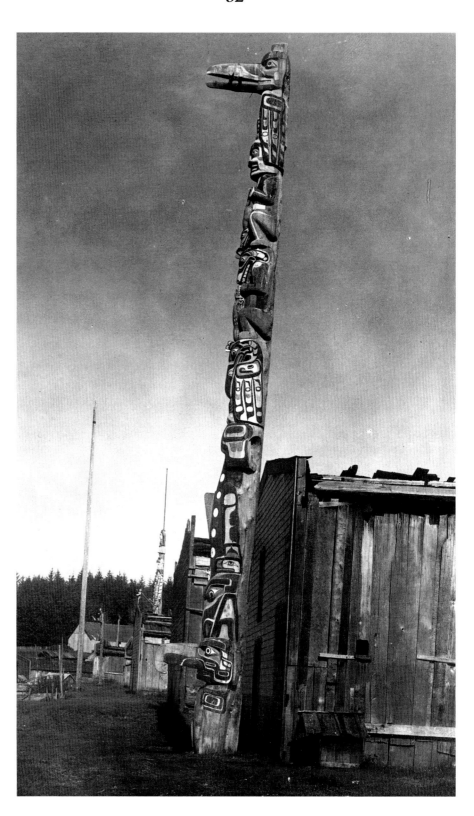

very thin strips of cedar bark. Sometimes they wove wool from goats or the hair of white dogs among the cedar fibers. The wool or hair—dyed yellow, blue, and black—was woven to create a multicolor design. The Northwest's best blanket makers were the Chilkat branch of the Tlingit tribe. Chilkat blankets were patterned with a jumble of squares that represented the faces, or sometimes just the eyes, of the animal spirits.

The likeness of a horse is depicted on a beaded bag made by a Native American artist.

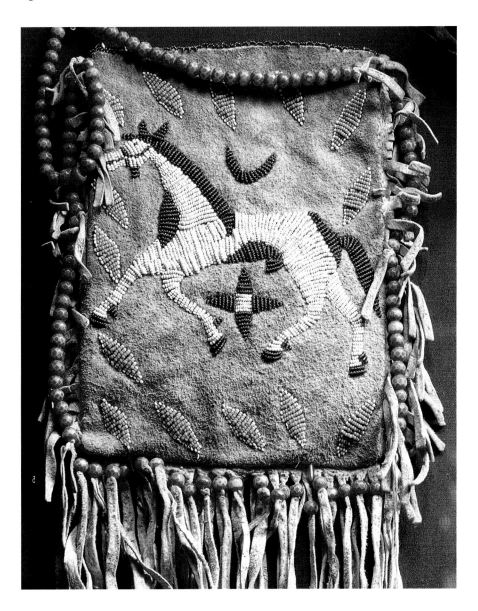

Potlatch guests also liked to receive pieces of coppers. Coppers were shields made out of pounded metal. The Northwest Coast Native Americans believed that these objects were like boxes that contained the souls of a family's spirit ancestors. A copper was therefore a family's most precious possession. Potlatch hosts who were willing to break up one of these treasures and give the pieces to their friends were thought to be very generous.

Potlatches were probably held many centuries ago. However, starting in late 1700s, the celebrations began to grow larger. At that time, traders from Europe and Russia started sailing to the Northwest Coast. In exchange for otter furs, they offered the Native Americans metal knives, glass beads, and cloth. The Native Americans began adding these trade items for their potlatch gifts. As they received more and more new goods from traders, the giveaways became bigger and bigger events. By the early 1900s, host families offered guests thousands of dollars worth of gifts. During huge potlatches, non-Native American, factory-made items such as sewing machines, pool tables, and gramophones (early record players) were given away.

Reviving the Old Ways

Potlatch celebrations confused the non-Native Americans who settled in the Northwest. They thought the events were peculiar and wasteful. They were also disturbed by the ceremonials held during the winter. White people found the frenzied dancing and strange costumes very frightening. When the United States and Canada took control over the Northwest region, their governments officially outlawed these ceremonies.

Some Native Americans ignored the laws and held potlatches anyway. Often their leaders were put in jail. Occasionally, white police officers broke up potlatches and

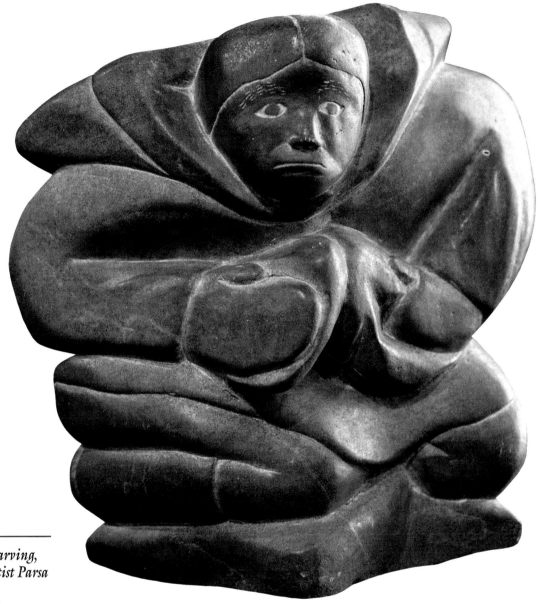

A soapstone carving, by Eskimo artist Parsa Anawtuk Povungnituk.

took all the gifts intended for the guests. These gifts were then sold to museums and art collectors.

As time passed, fewer and fewer families decided to host potlatches. Laws prohibiting ceremonies discouraged some. Many more had merely become too poor for the custom. After losing their lands to whites, the Northwest Coast Native Americans had trouble making a living. By the 1920s, most families were not left with enough money or possessions to hold a potlatch.

✳

56

The end of the potlatch and the winter ceremonials was devastating to Northwest artists. They no longer had any reason to make the masks, blankets, carvings, and coppers that had been so important to their people. The laws prohibiting ceremonies were finally lifted in 1951, but by this time most Northwest Coast Native Americans had stopped creating art.

Some artists, however, continued their work. They also taught young people how to carve wood and weave blankets. By the 1960s, many of these young artists found that they could sell their artwork to white people who had learned about their art from seeing it in museums. Some of the most successful of these artists painted pictures on canvas or printed them on silk fabric. These techniques are new, but the images they create are similar to those that the Northwest Native Americans used to paint on their houses or weave into Chilkat blankets.

Other artists of Northwest tribes choose not to sell their work. They believe that their art is too important to market it to outsiders. The potlatches and winter ceremonials held today are far less grand than those of the past. Even so, Native American artists are pleased to create the objects used during these events. They are grateful and proud that once again, like their ancestors, they can help make possible the ceremonies that their people have long valued.

Glossary

beadwork The decoration of clothing and other objects using multicolor glass beads. Native Americans in the Great Plains, the Northeast, and the Great Lakes region excelled at creating beadwork.

Chilkat blanket A type of woven blanket created by Northwest Coast Native Americans from cedar bark and goat's wool or dog hair. These blankets are named after the Chilkat group of the Tlingit tribe, which included many talented weavers.

coppers A type of valuable copper shield that was treasured by the Native Americans of the Northwest Coast. Owners of coppers believed they were like boxes that contained the souls of their dead ancestors.

dry painting A picture that was made by Southwest Native Americans from crushed rocks of different colors. Dry paintings were used in ceremonies to help cure the ill.

effigy A sculpture or other type of object made in the shape of an animal, often a human being. Many of the effigies that were created by ancient Native Americans were in the form of enormous mounds of earth.

False Faces Painted wood masks worn by the Iroquois during healing ceremonies. Carved into the trunk of a living tree, False Faces were thought to retain part of the tree's living spirit.

fur trade Trade network in which Native Americans offered the furs of animals (usually beavers) to non-Native American traders for manufactured goods from Europe. Through the fur trade, Native American artists obtained materials such as glass beads, paints, and silk ribbons for the first time.

kachina One of hundreds of supernatural beings that many Pueblo believe live in the American Southwest. Wooden dolls of the kachinas are given to Pueblo children to teach them about these important spirits.

ledger drawing A drawing made with crayons and pencils on paper by Plains artists in the late 1800s. U.S. soldiers and other intruders on the plains provided these materials.

Midewiwin A special medicine dance performed by a society of healers among the Ojibwa, called the Grand Medicine Society, or Medicine Lodge Society.

parfleche A type of storage bag that Plains Indians used to carry their belongings.

potlatch A ceremony held by the Tlingit, Kwakiutl, and other Northwest Coast tribes. At a potlatch, the hosts offered their relatives and friends costly food and gifts to display their wealth and power within their village.

powwow A conference or gathering of Native Americans; often characterized by feasts, dancing, and celebration.

pueblo Native American village made of large clay-brick dwellings. The many Southwest tribes that have lived in these types of houses, such as the Hopi and the Zuni, are known as the Pueblo people.

quillwork The decoration of clothing and other objects with dyed and flattened porcupine quills. Many Native

Americans in the Northeast, the Great Plains, and the Great Lakes region were particularly skilled at quillwork.

reservation A tract of land that was set aside by the United States for a group of Native Americans. Usually, reservations were small plots of poor-quality land that were offered to Native Americans only after white settlers had seized their lands.

ribbonwork The decoration of clothing and other objects with silk or cotton ribbons. Native Americans throughout the East, especially the Seminole of Florida, were well known for their ribbonwork.

tipi A cone-shaped portable house made from a large animal hide cover and a frame of wooden poles. Plains Indians decorated their tipis with paint.

totem pole A large wooden pole carved with a series of pictures erected outside the homes of important families among the Native Americans of the Northwest Coast. The images on a totem pole told the story of an animal spirit from which the family believed it was descended.

treaty A written agreement made between two groups of people. The Native Americans of North America signed many treaties with the United States and Canada. These governments often broke the promises they made to various Native American groups.

tribe A group of Native American people who share the same religious, cultural, and social beliefs. When Europeans first came to North America, there were more than 350 tribes living on the continent.

wampum Purple and white tube-shaped beads made from shells. Among the Iroquois, wampum was woven into patterns to form belts that celebrated important events, such as the signing of a treaty. Wampum was also used as a form of currency, a practice started by European settlers to conduct transactions with Native Americans.

WALT DISNEY SCHOOL LIBRARY

✳

60

Further Reading

complexAnderson, Peter. *Maria Martinez: Pueblo Potter.* Chicago: Childrens Press, 1992.

Baylor, Byrd. *When Clay Sings.* New York: Macmillan Publishing Company, 1987.

Beyer, Don E. *The Totem Pole Indians of the Northwest.* New York: Watts, 1991.

Brooks, B. *The Sioux.* Vero Beach, FL: Rourke, 1989.

D'Apice, Mary. *The Pueblo.* Vero Beach, FL: Rourke, 1990.

DeCesare, Ruth. *Myth, Music & Dance in the American Indian.* Van Nuys, CA: Alfred Publishers, 1988.

Gates, Freida. *North American Indian Masks.* New York: Walker and Company, 1982.

Grant, Bruce. *Concise Encyclopedia of the American Indian.* Avenal, NJ: Outlet Book, 1989.

McCall, Barbara. *The Apache.* Vero Beach, FL: Rourke, 1990.

Noble, David. *Houses Beneath the Rock: The Anasazi of Canyon de Chelly & Navajo National Monument.* Santa Fe, NM: Ancient City Press, 1992.

Silverberg, Robert. *The Moundbuilders.* Athens, OH: Ohio University Press, 1986.

Sneve, Virginia H., selected by. *Dancing Teepees: Poems of American Indian Youth.* New York: Holiday, 1991.

Stan, Susan. *The Navajo.* Vero Beach, FL: Rourke, 1989.

Wilbur, C. Keith. *Indian Handcrafts.* Old Saybrook, CT: Globe Pequot, 1990.

Index

Photo credits
Cover and pages 10, 15, 18, 24, 26, 36, 45: ©Blackbirch Press, Inc.; p. 6: ©Adelheid Howe, 1983; pp. 9, 16, 29, 32–33, 39, 42, 48, 52: Library of Congress; pp. 12, 38: North Wind Picture Archives; p. 21: National Park Service; p. 40: ©Craig J. Brown/Liaison International; p. 46: ©Lawrence Migdale/ Photo Researchers, Inc.; p. 50: ©Theo Westenberger/Gamma Liaison; p. 53: ©Gary Retherford/Photo Researchers, Inc.; p. 55: ©Dr. Charles R. Belinky/Photo Researchers, Inc.

WALT DISNEY MAGNET SCHOOL